This Sugar Skull Coloring Book Belongs To:

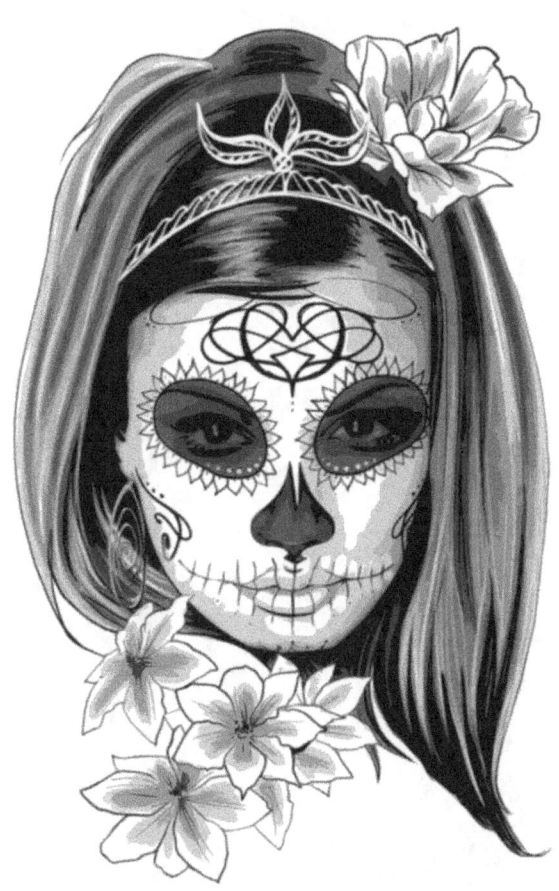

Copyright

© Martin Roch 2019 Penny Lane Books

All Rights Reserved

Image Title _____

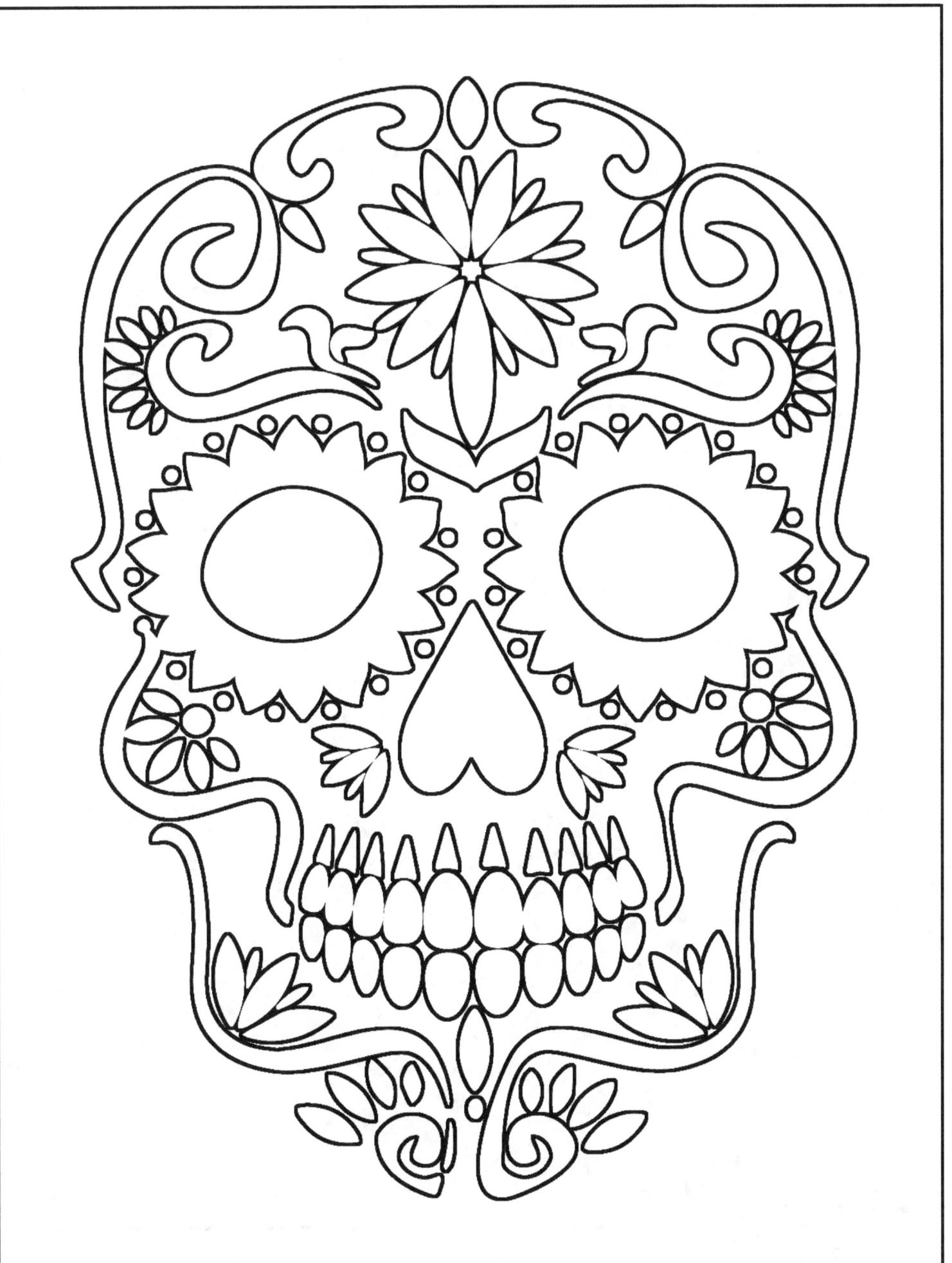

Image Title _____

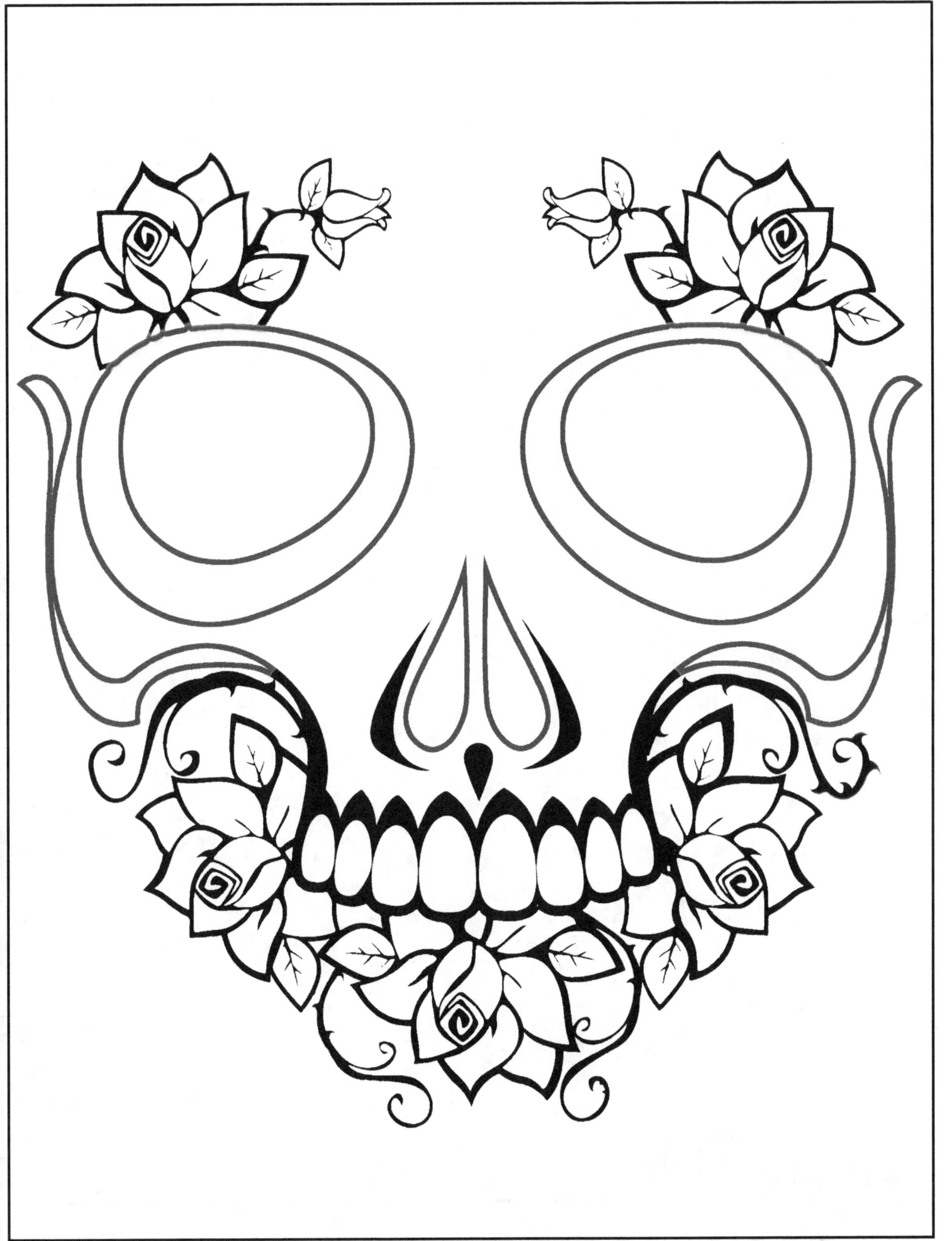

Image Title _____

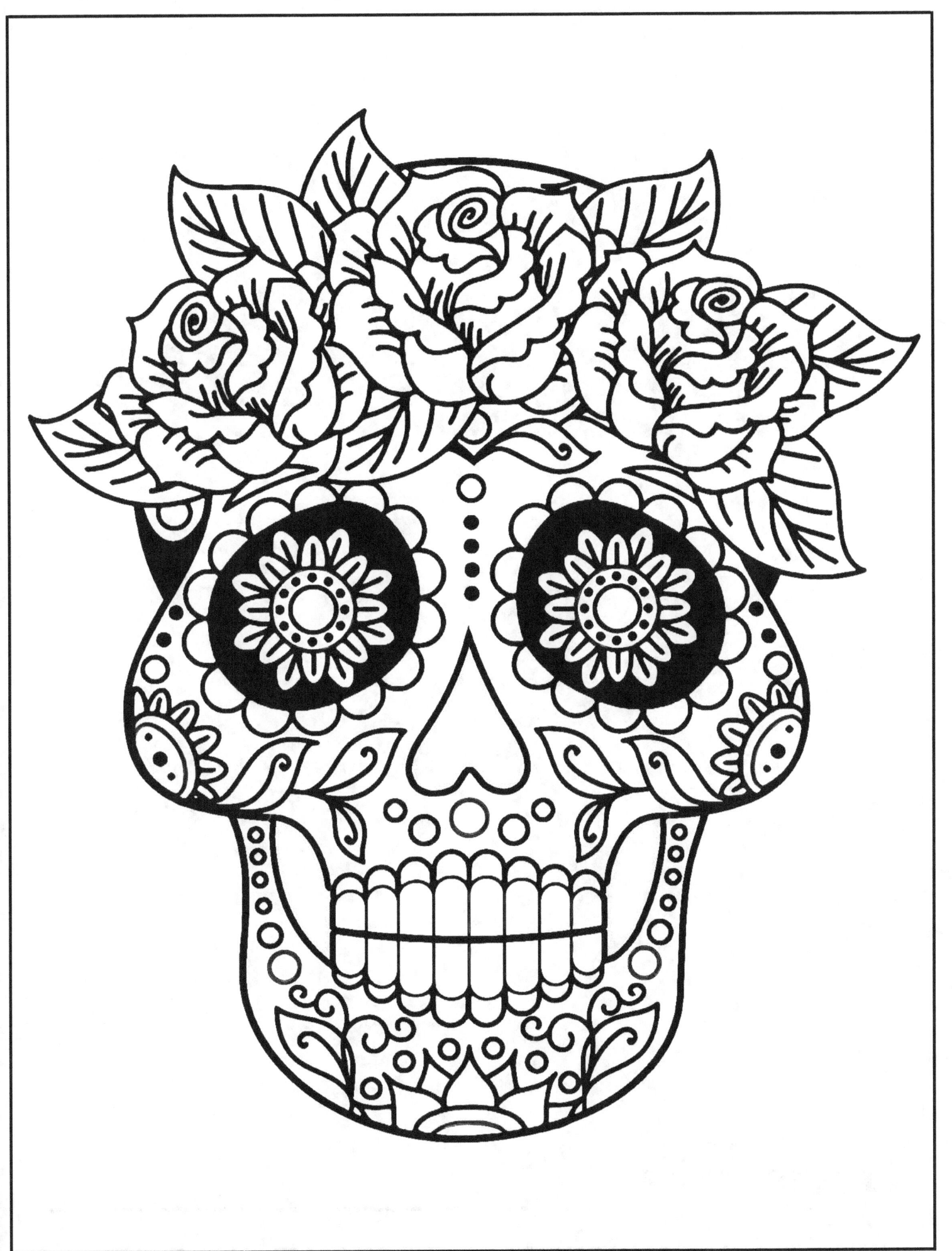

Image Title _____

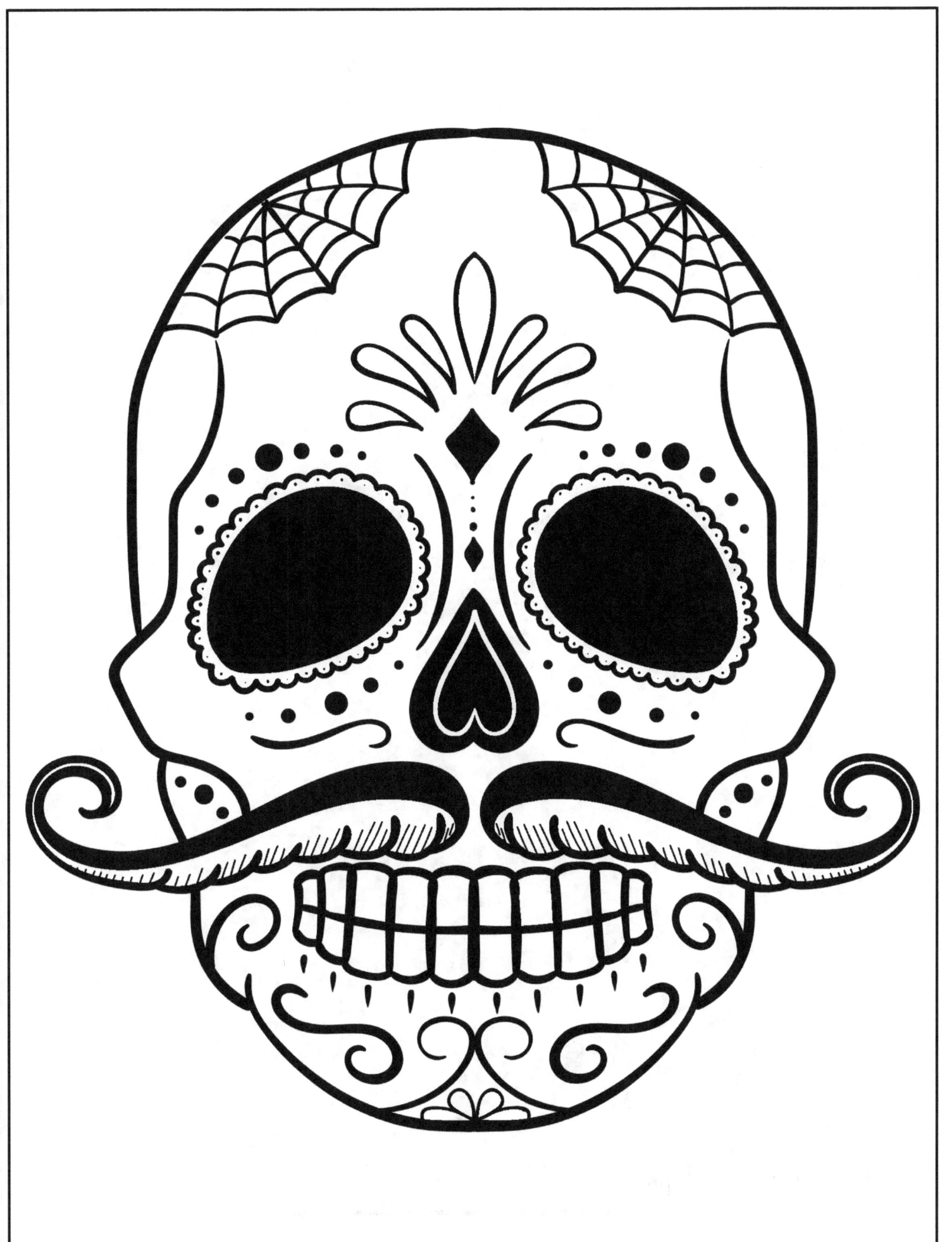

Image Title _____

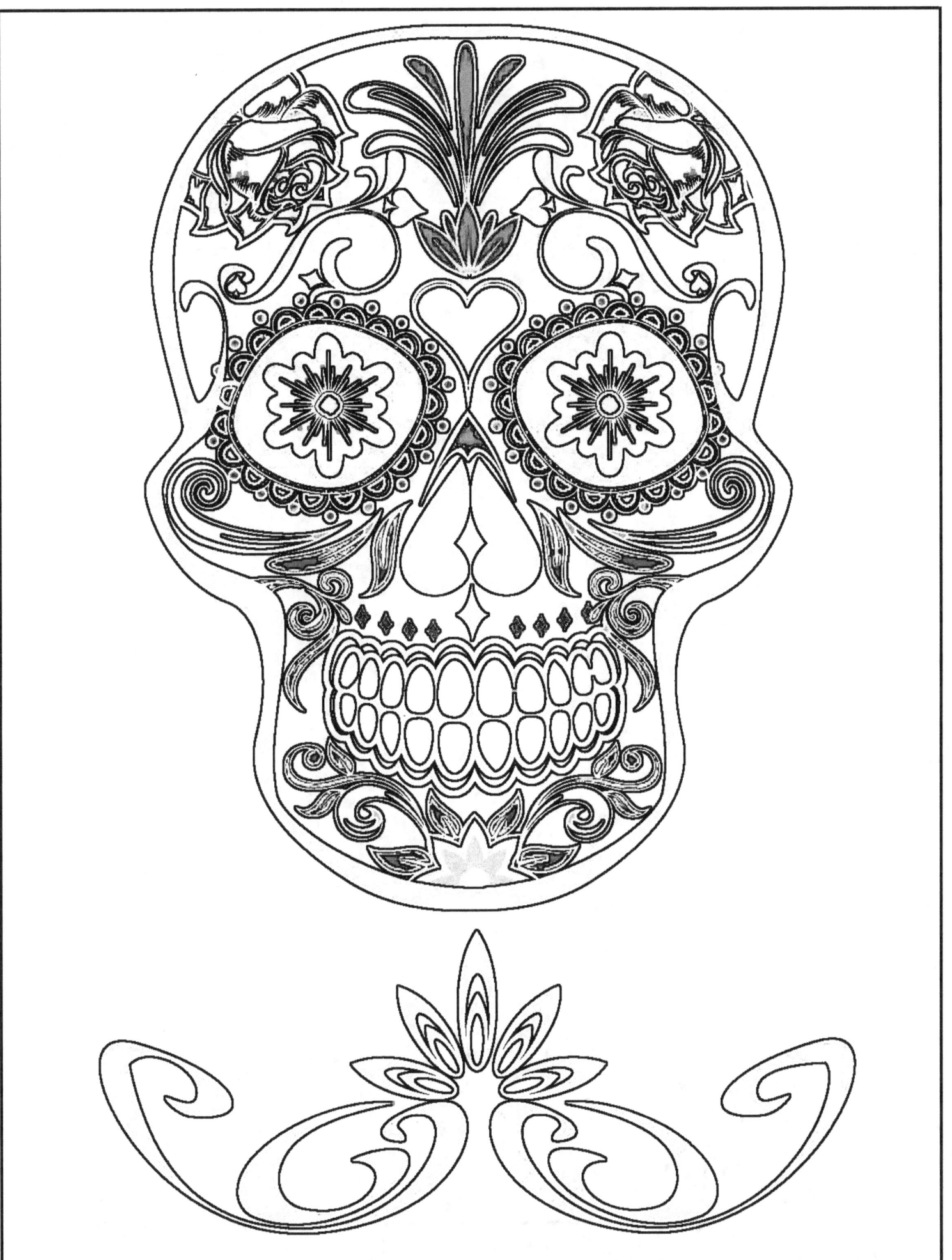

Image Title _____

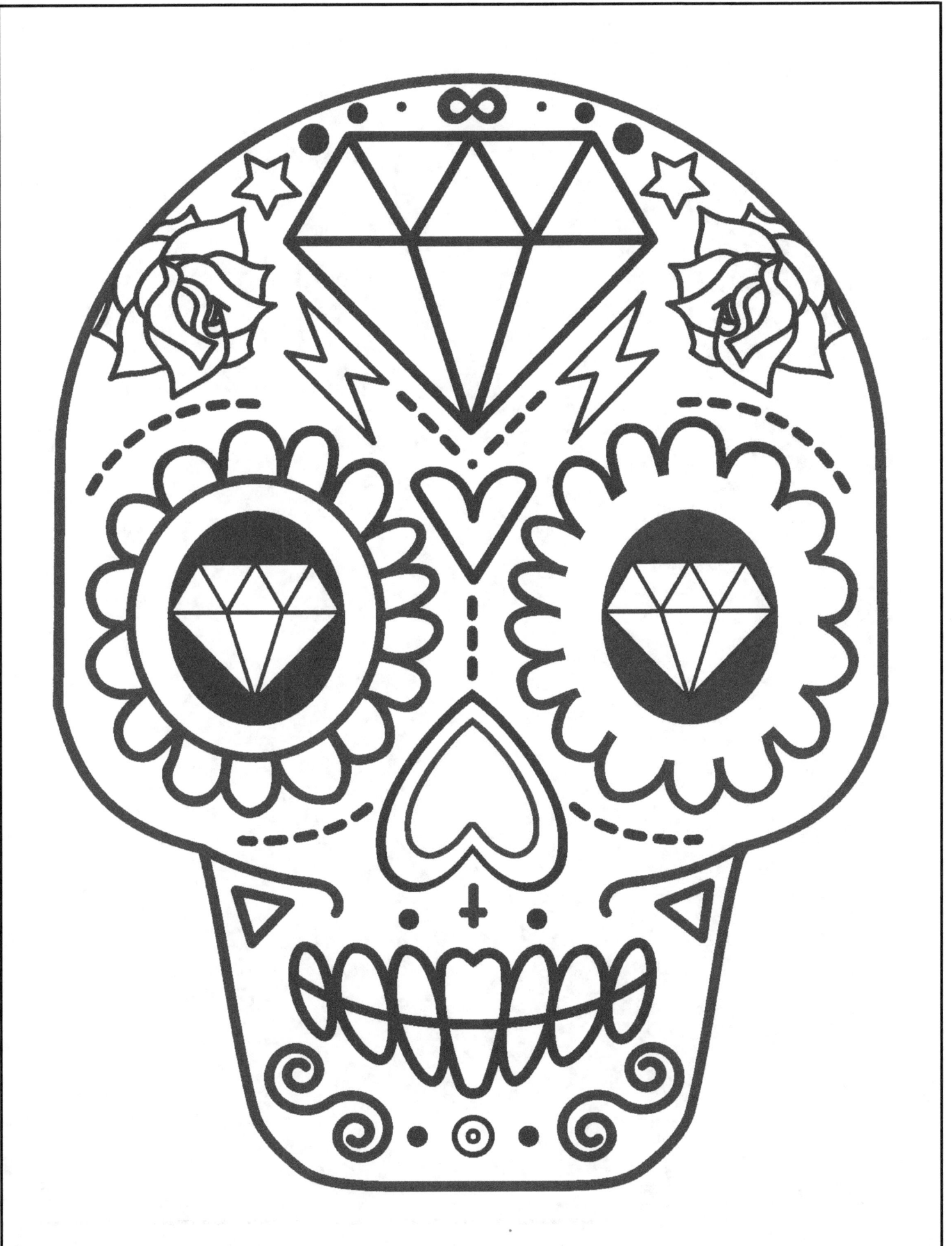

Image Title _____

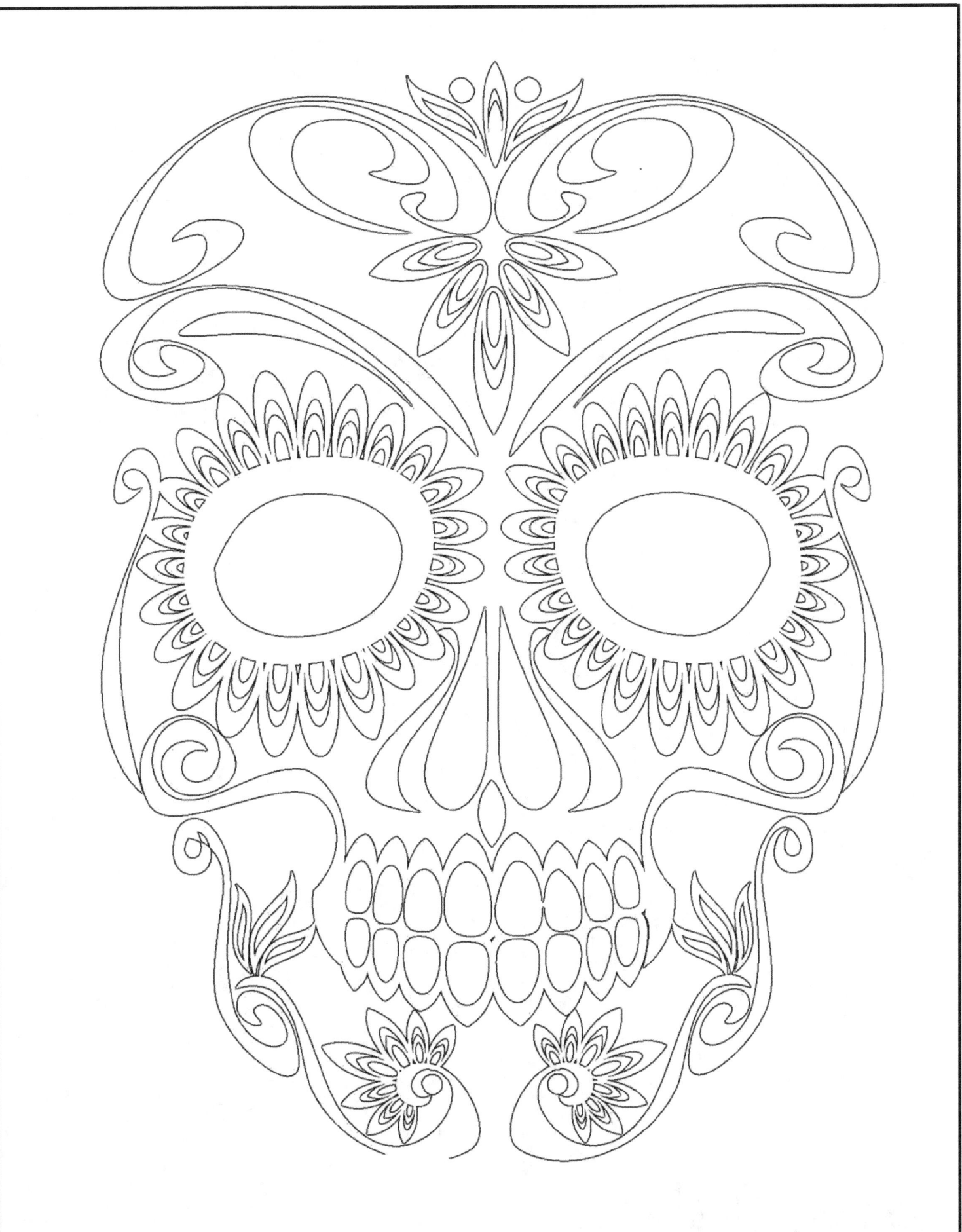

Image Title _____

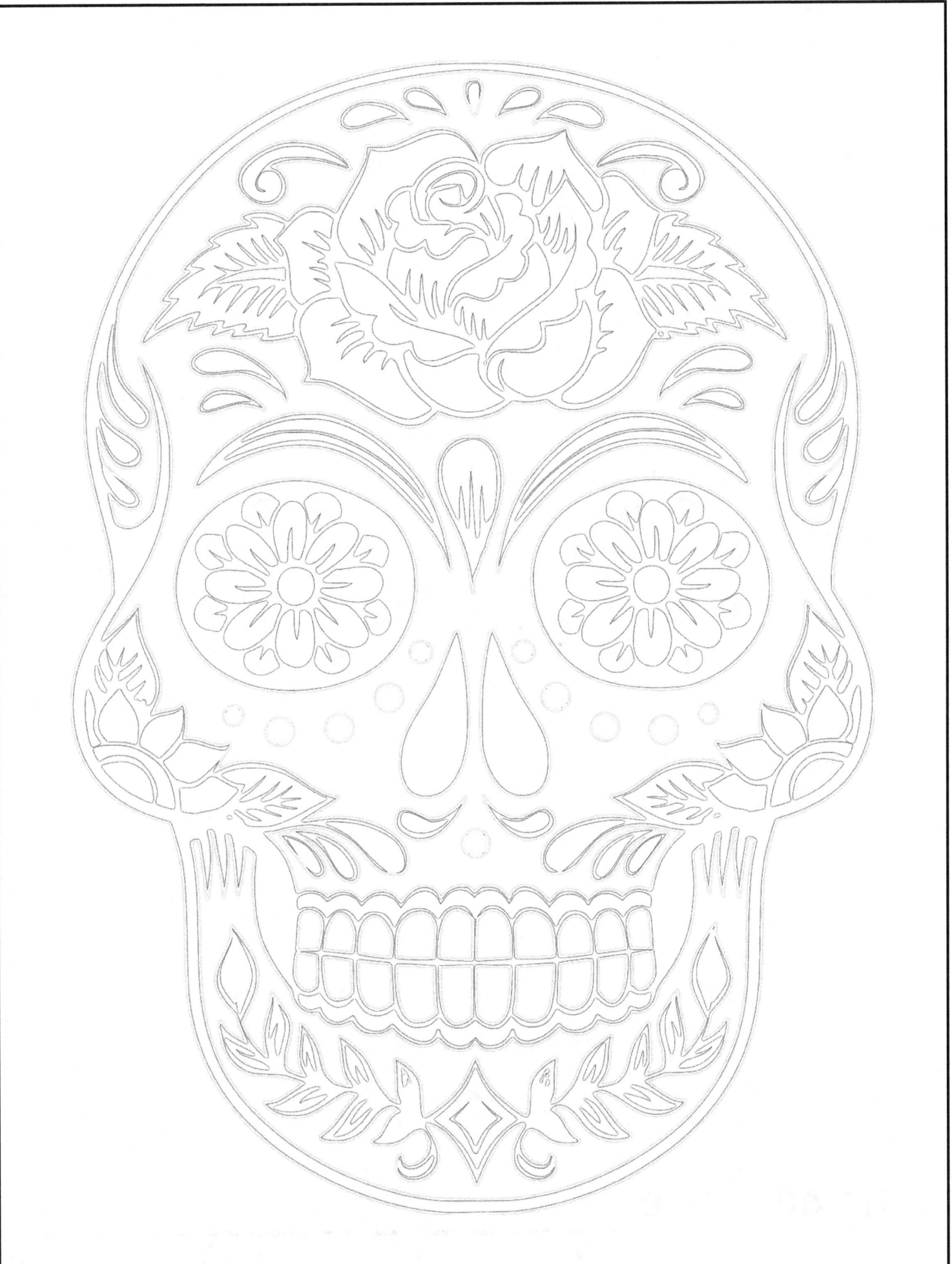

Image Title _____

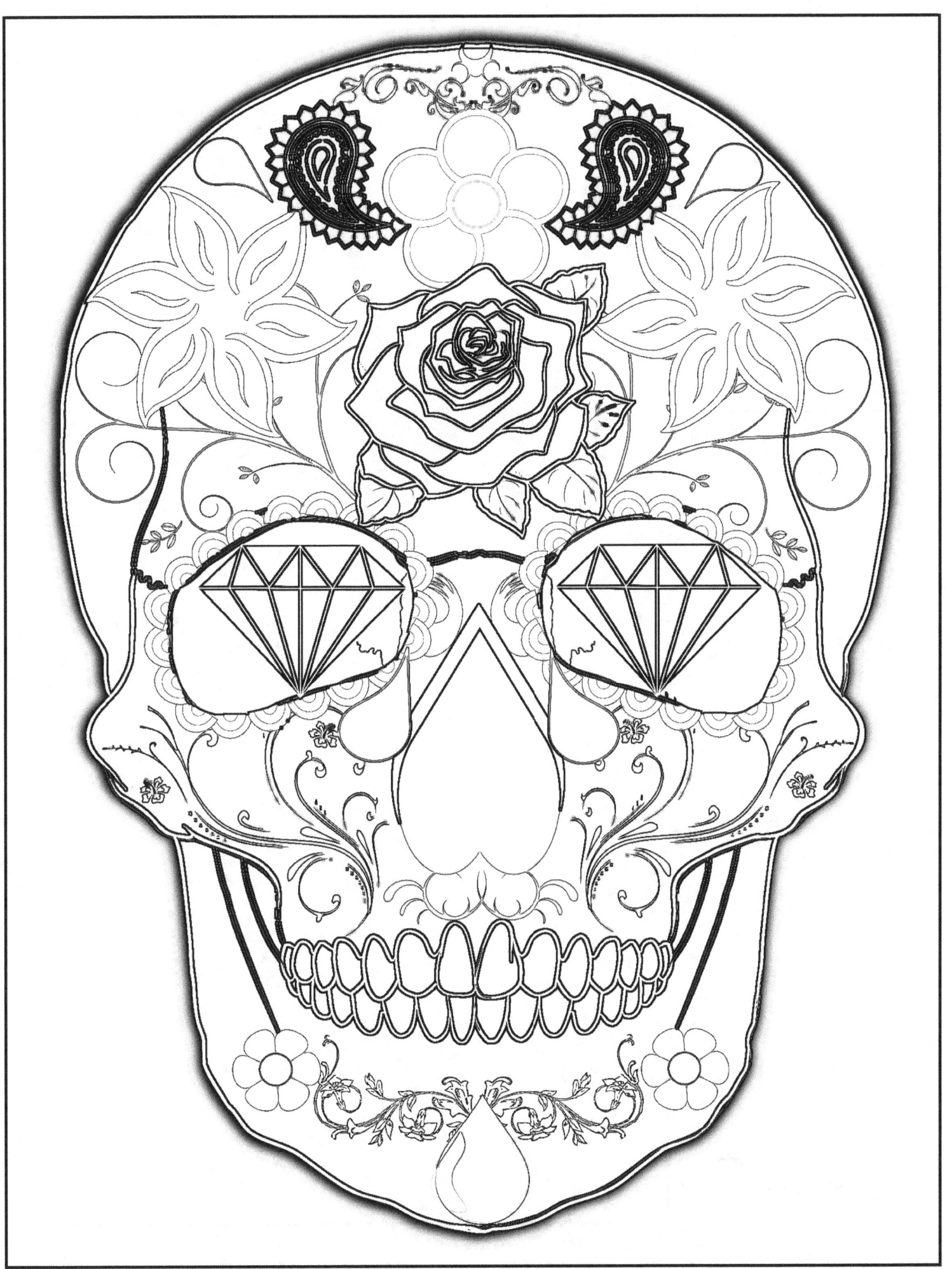

Image Title _____

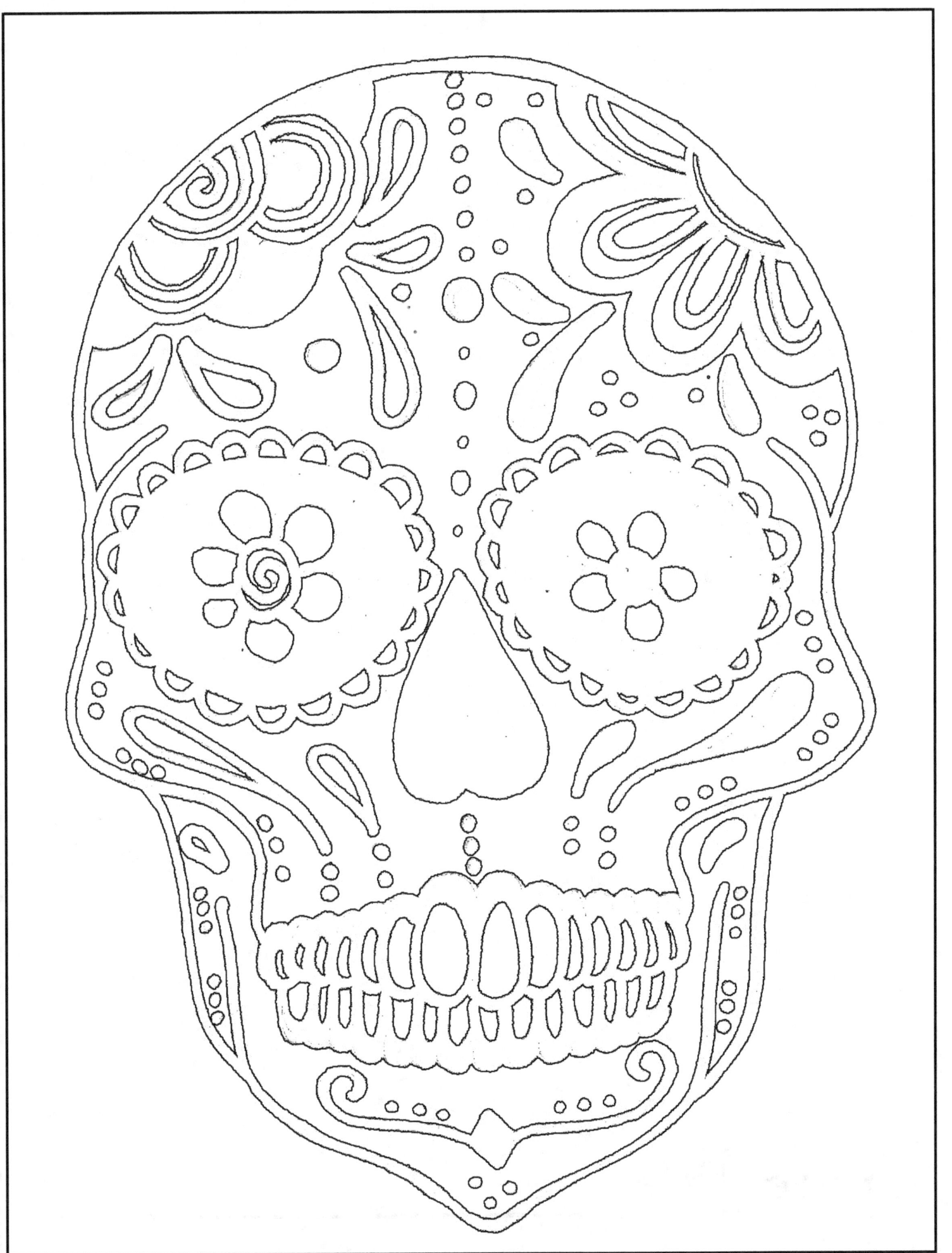

Image Title _____

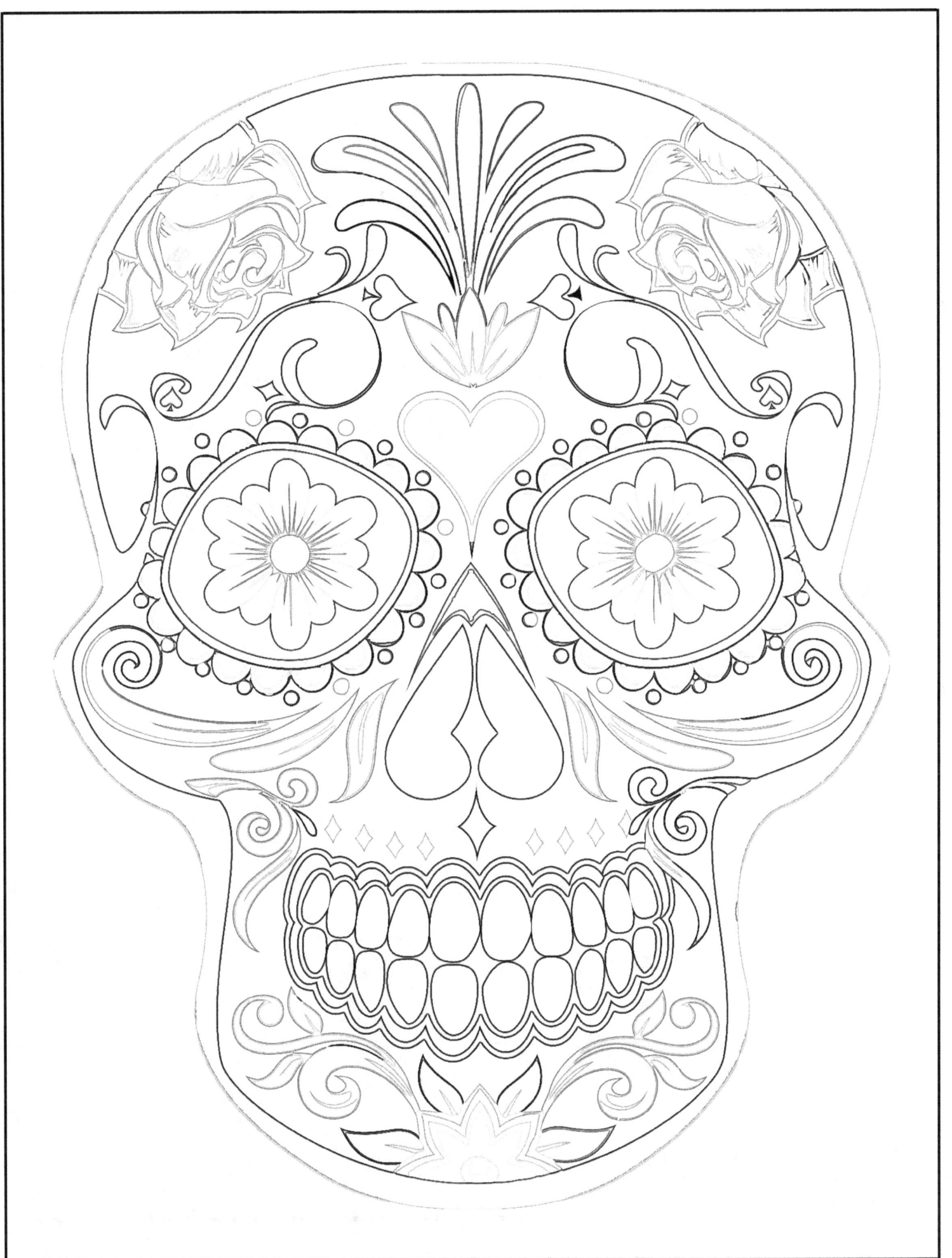

Image Title _____

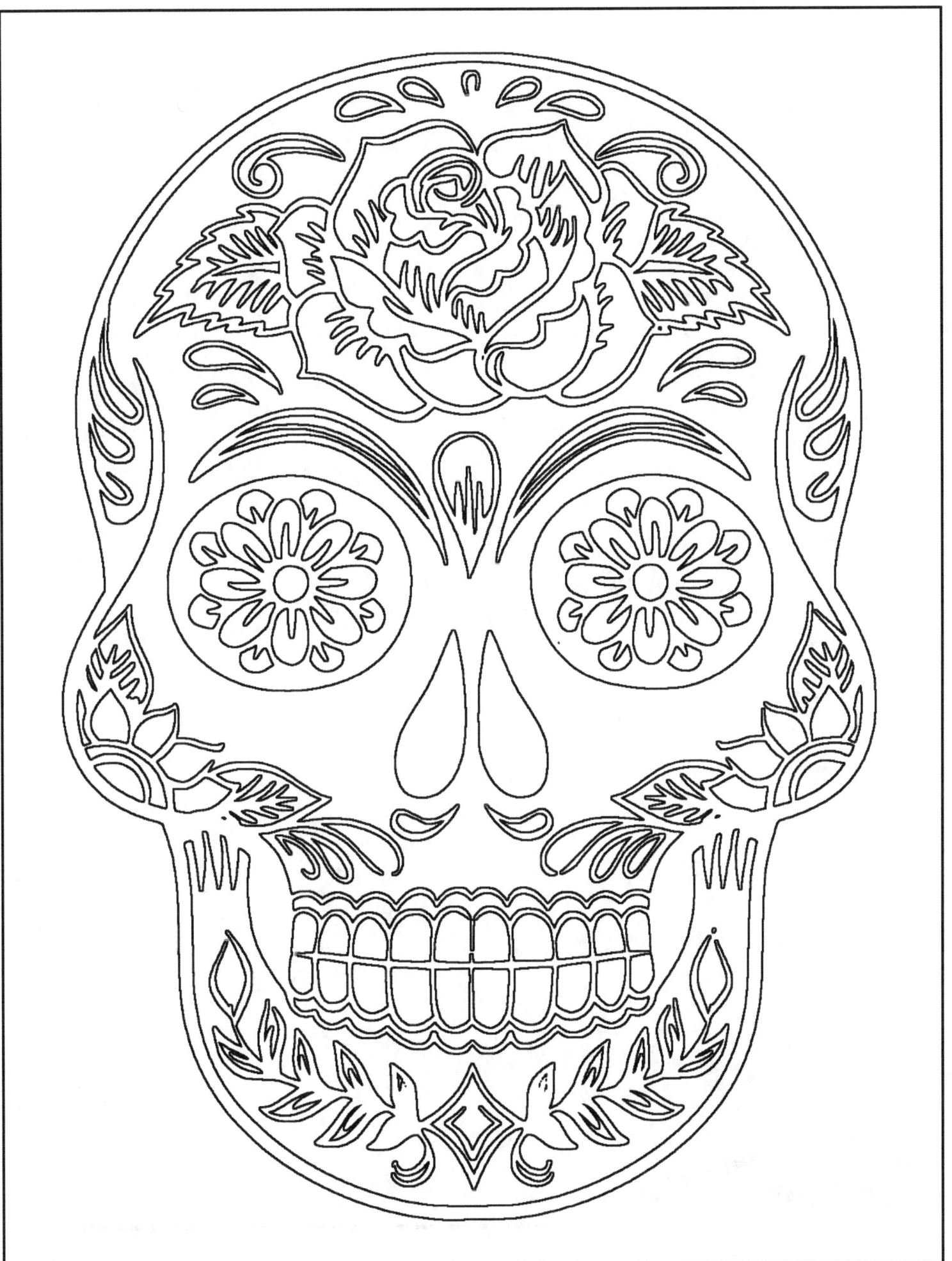

Image Title _____

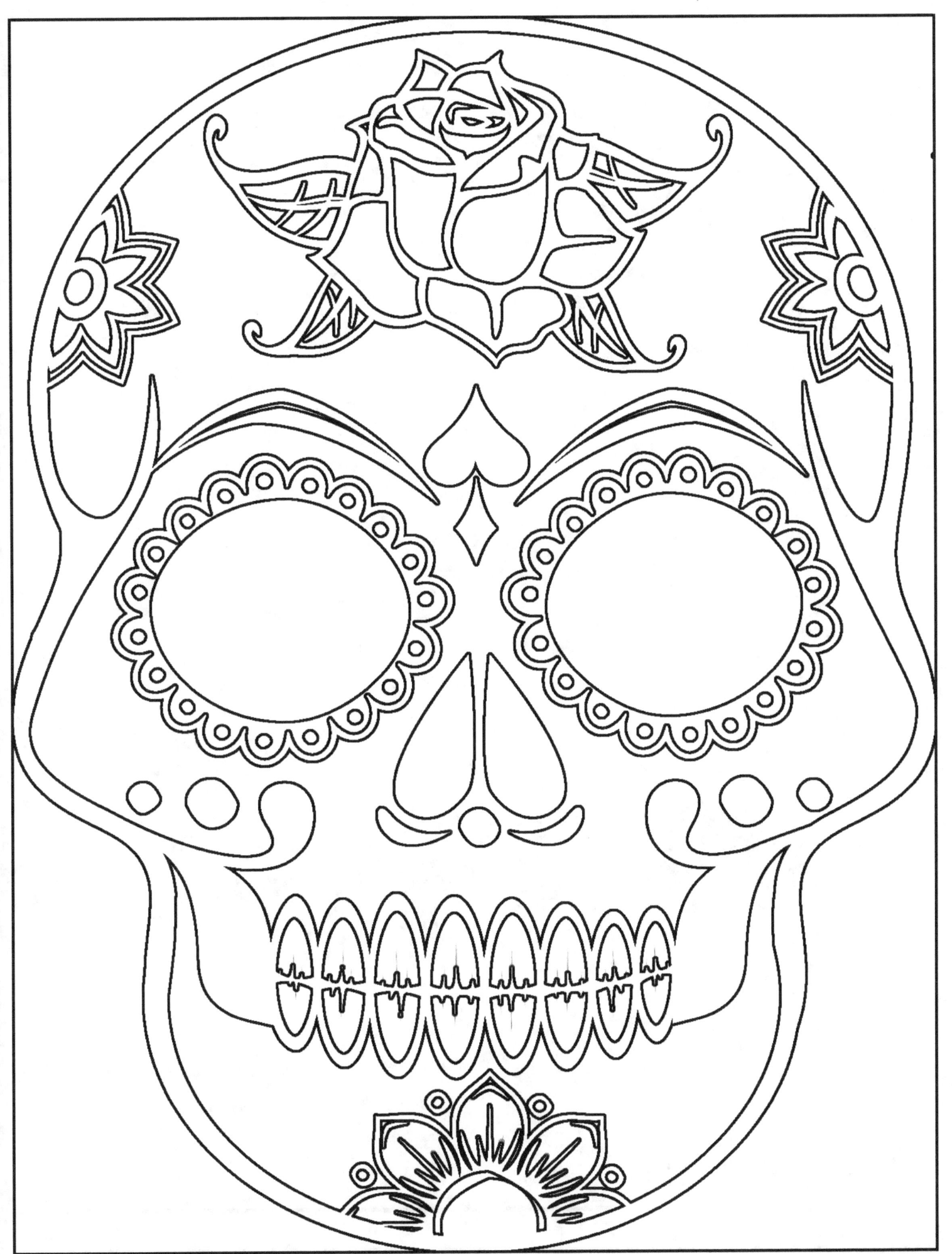

Image Title _____

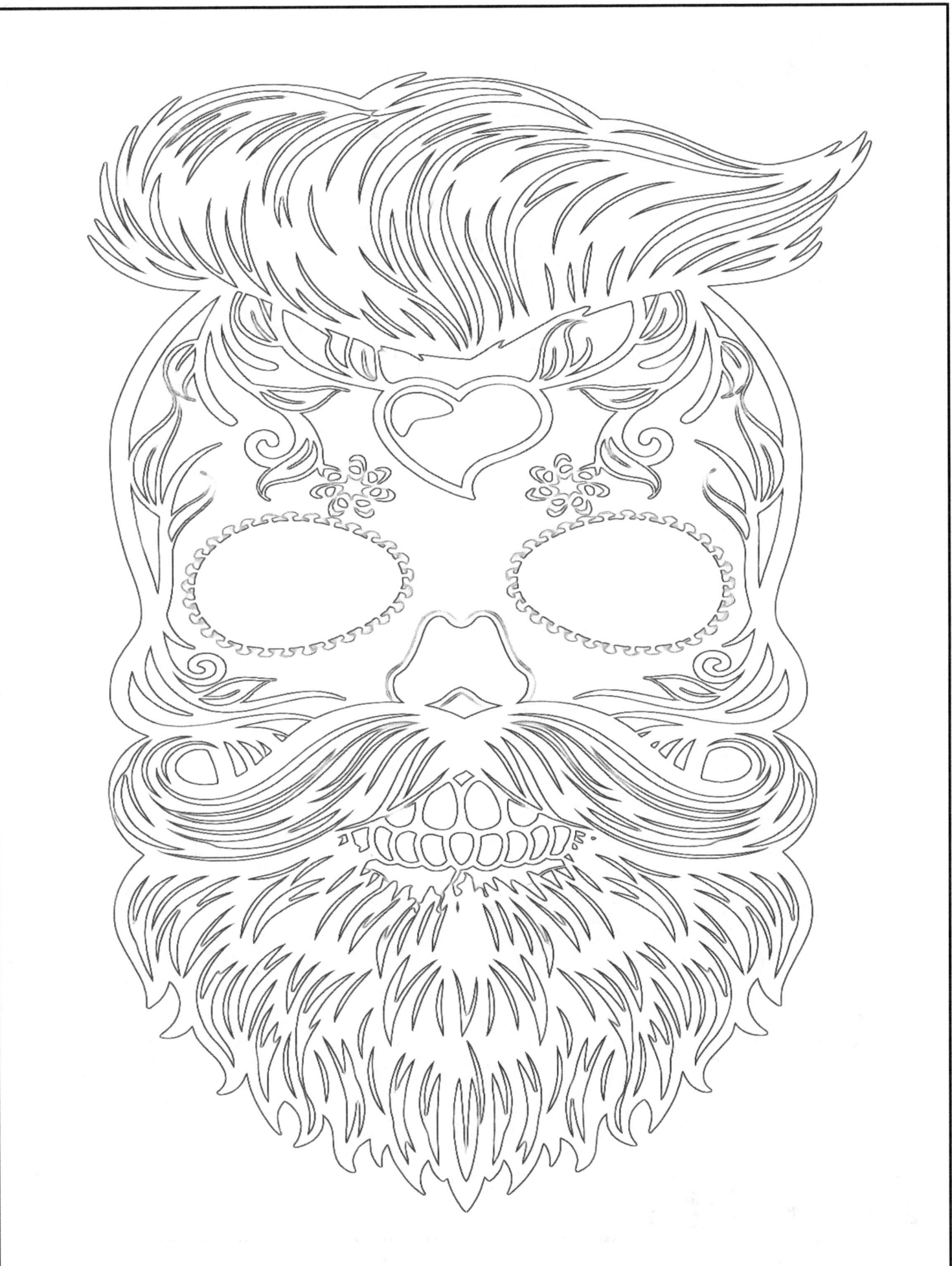

Image Title _____

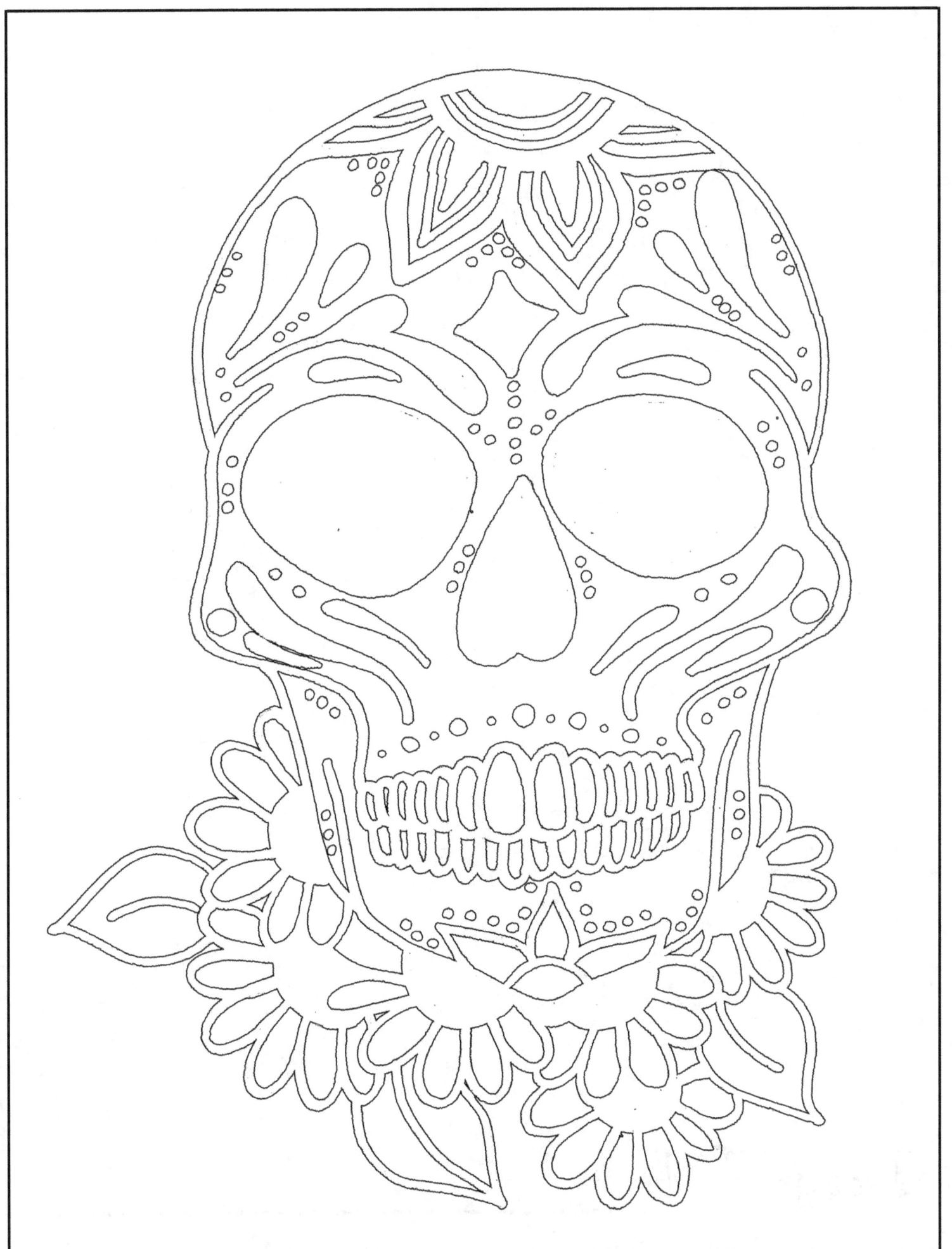

Image Title _____

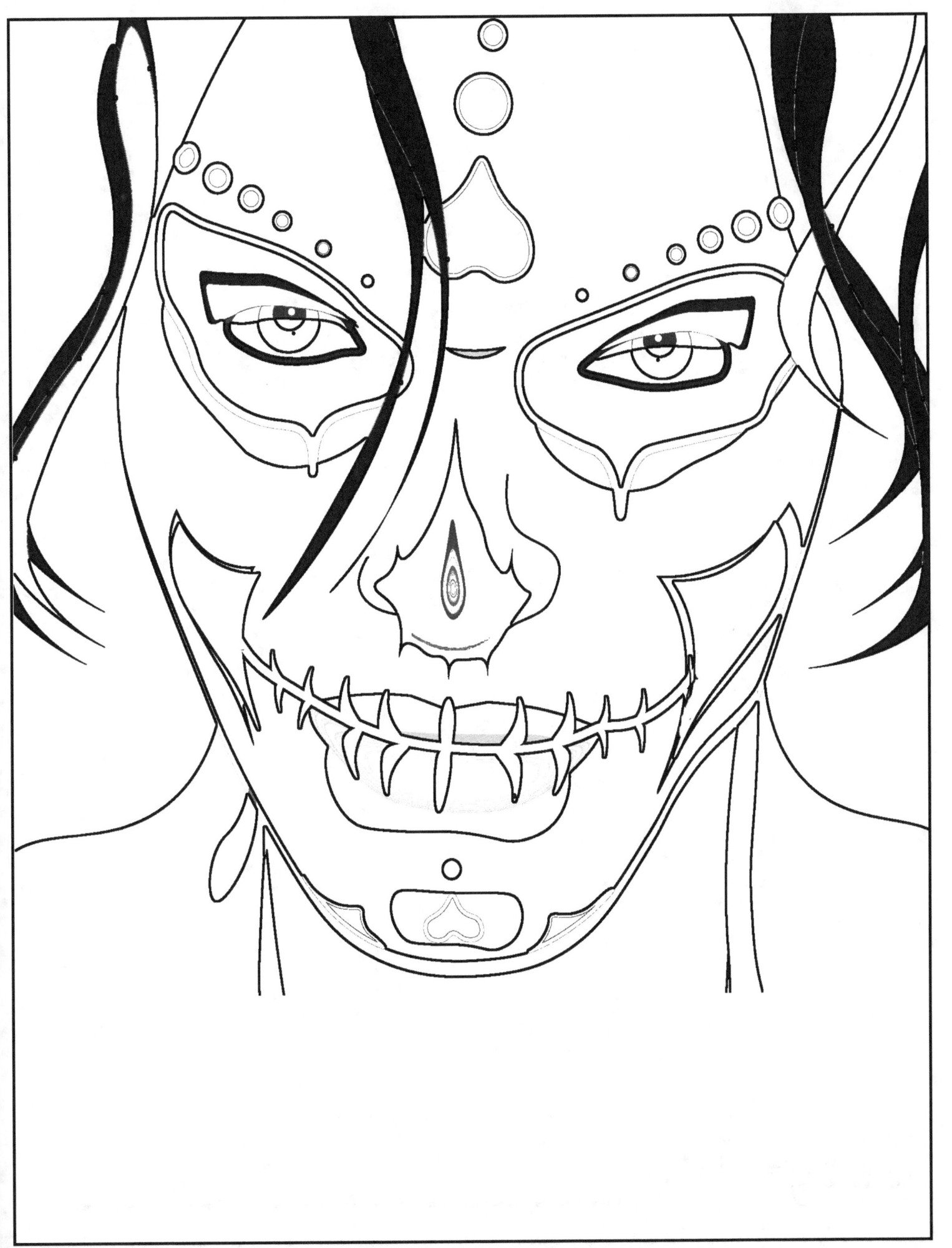

Image Title _____

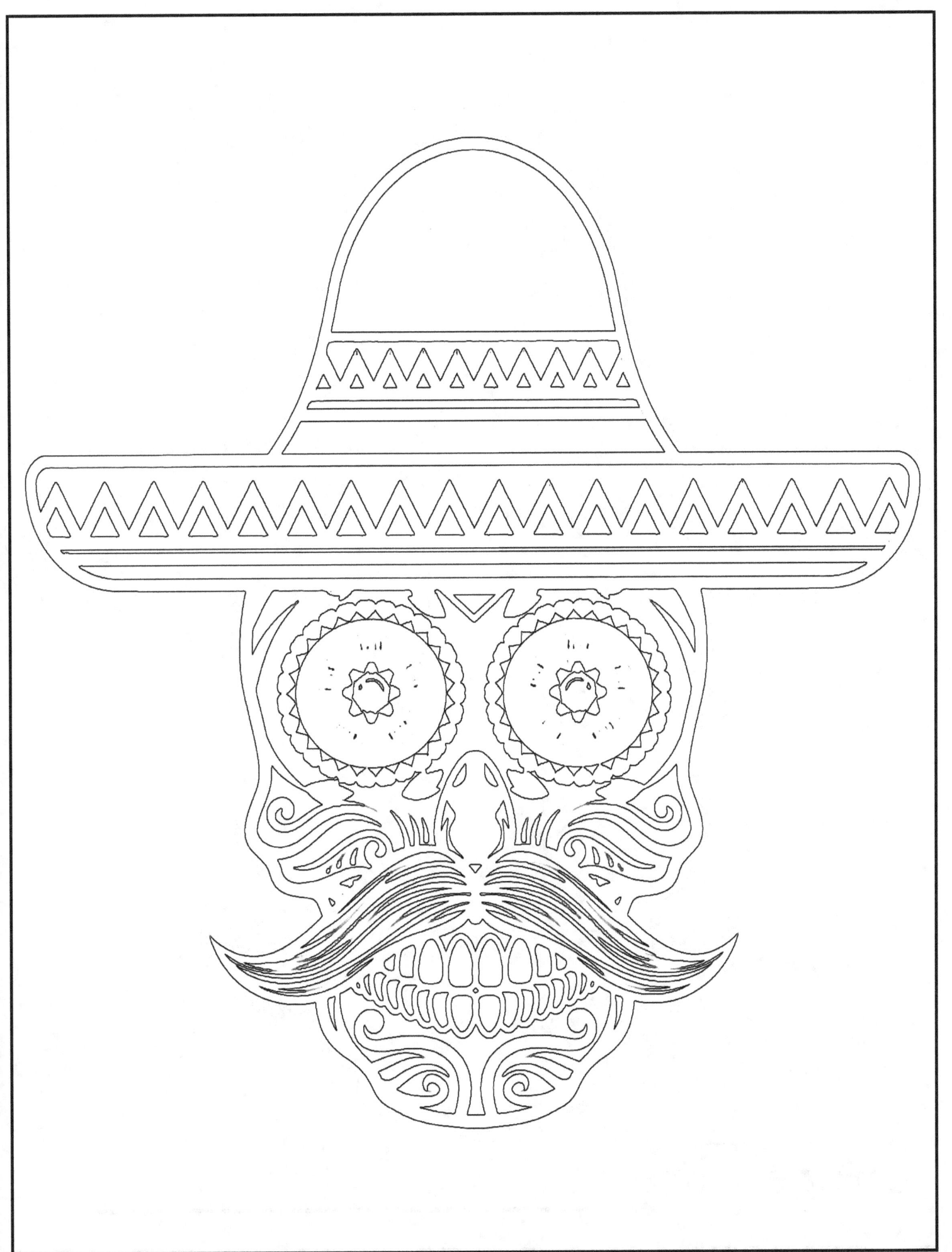

Image Title _____

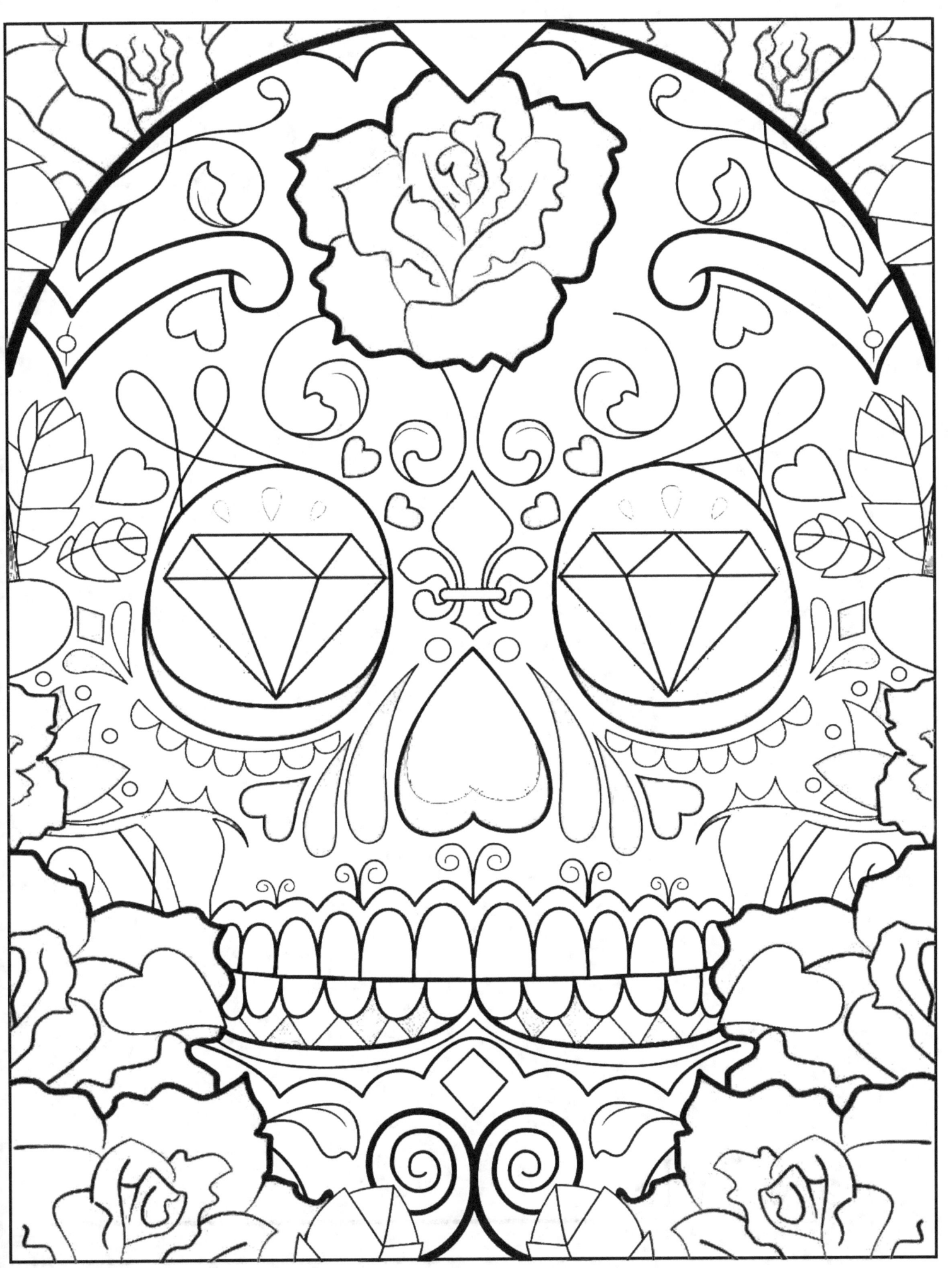

Image Title _____

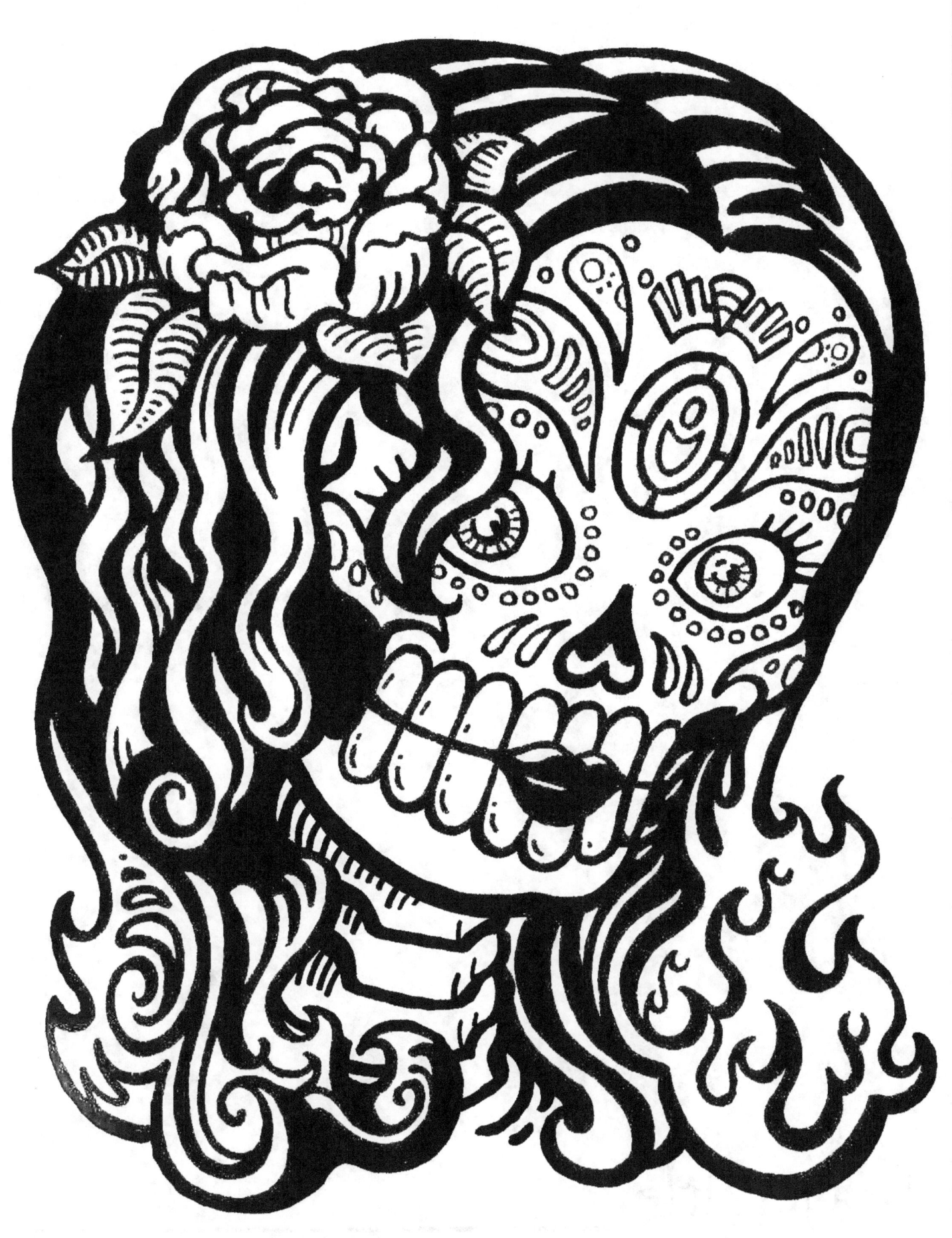

Image Title _____

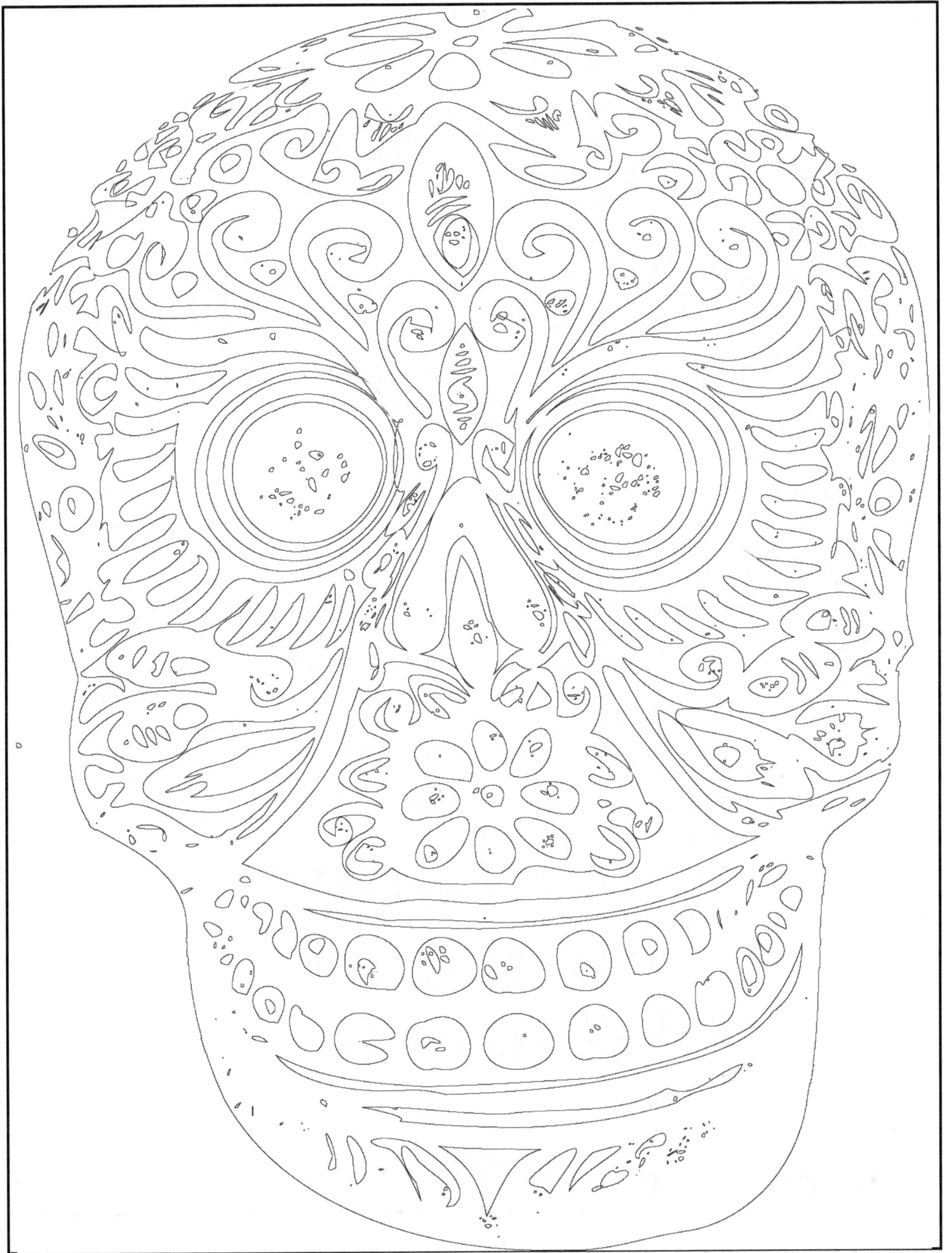

Image Title _____

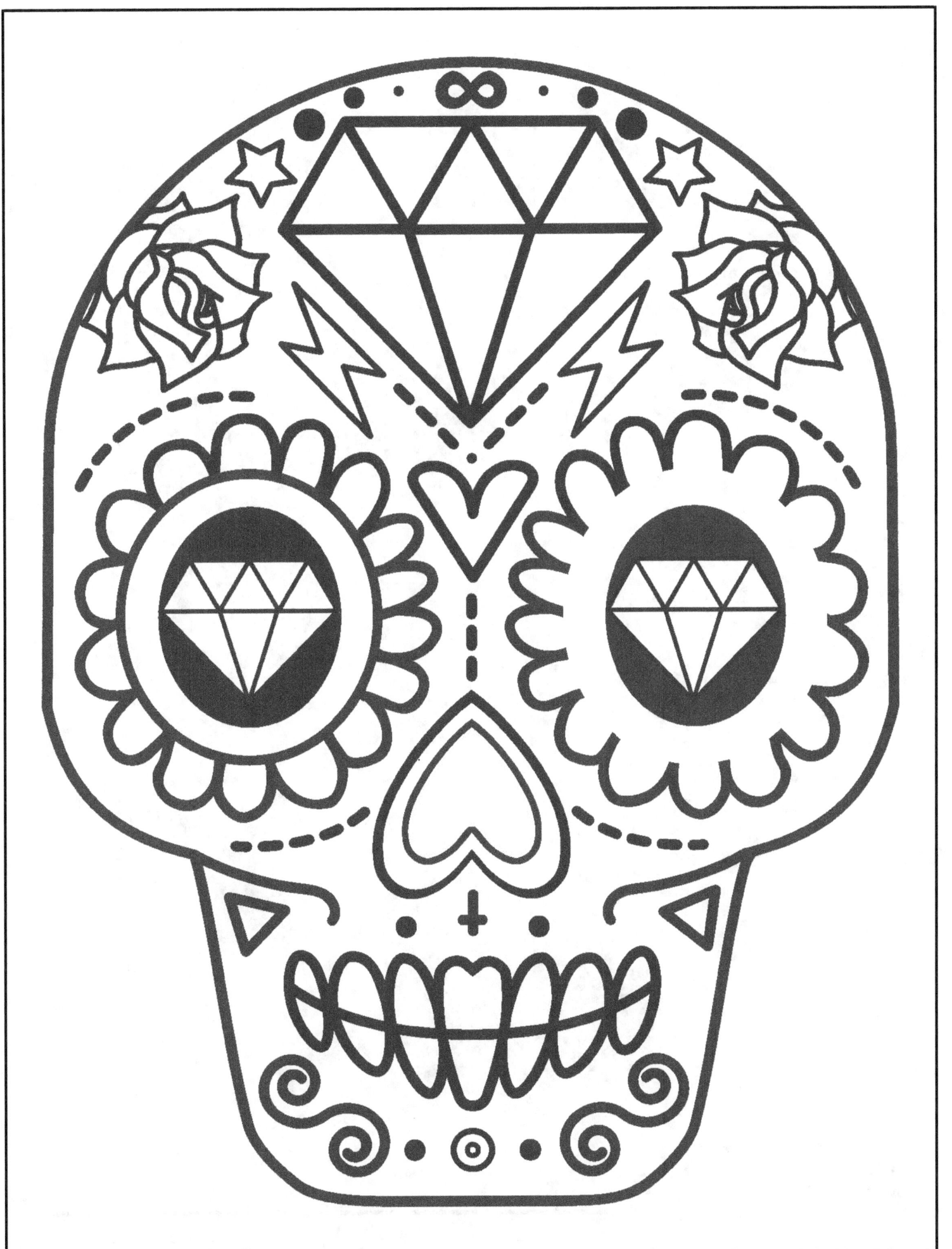

Image Title _____

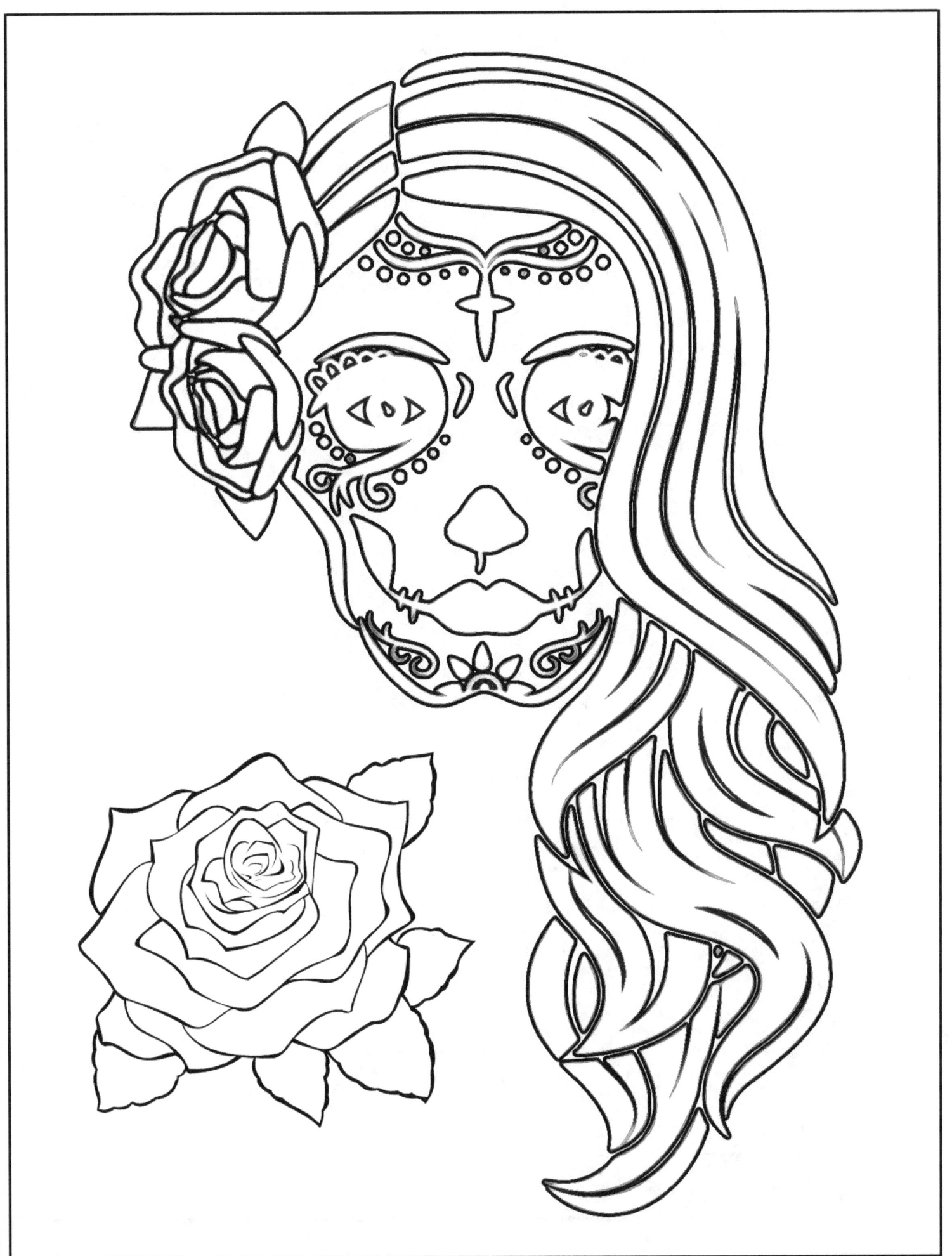

Image Title _____

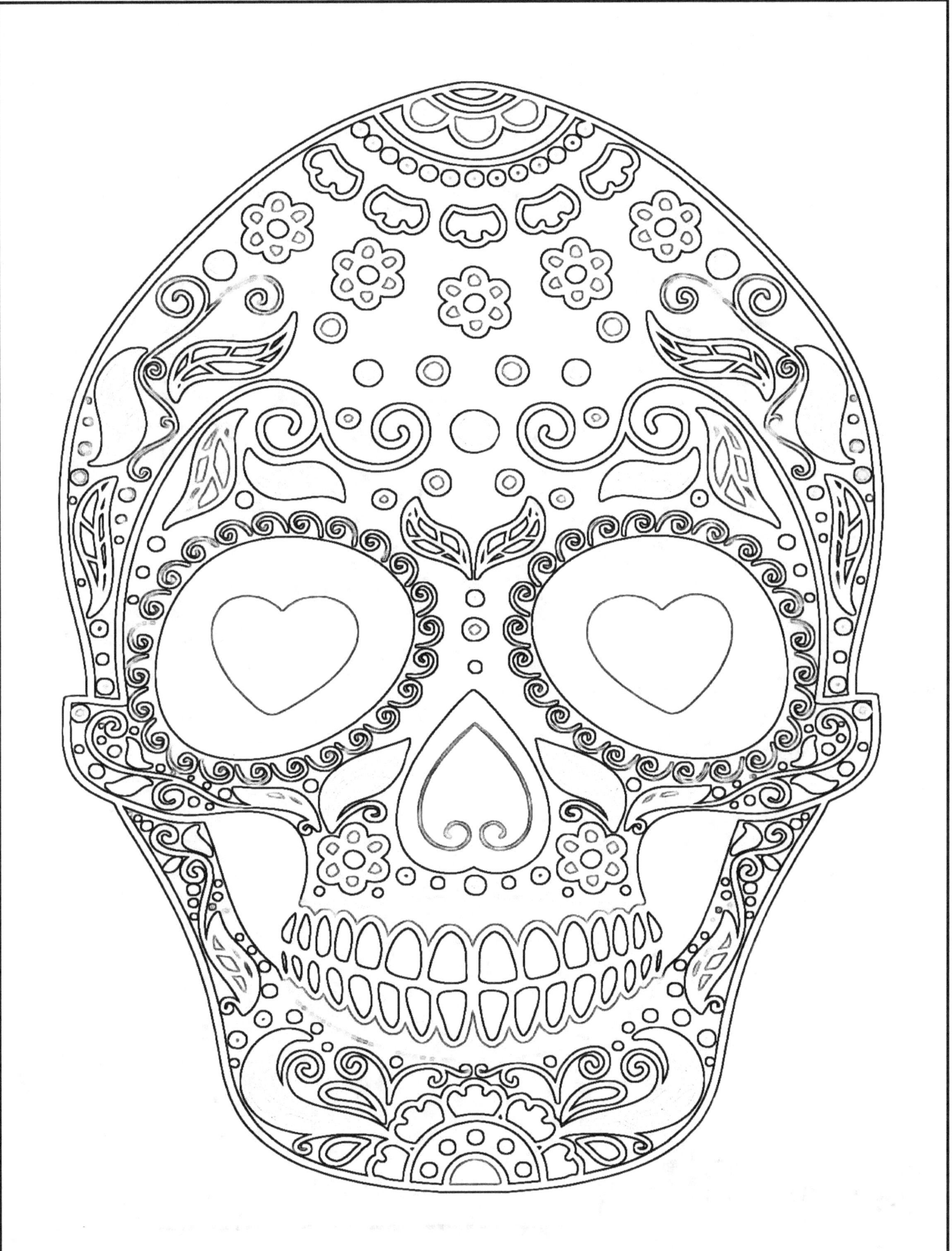

Image Title _____

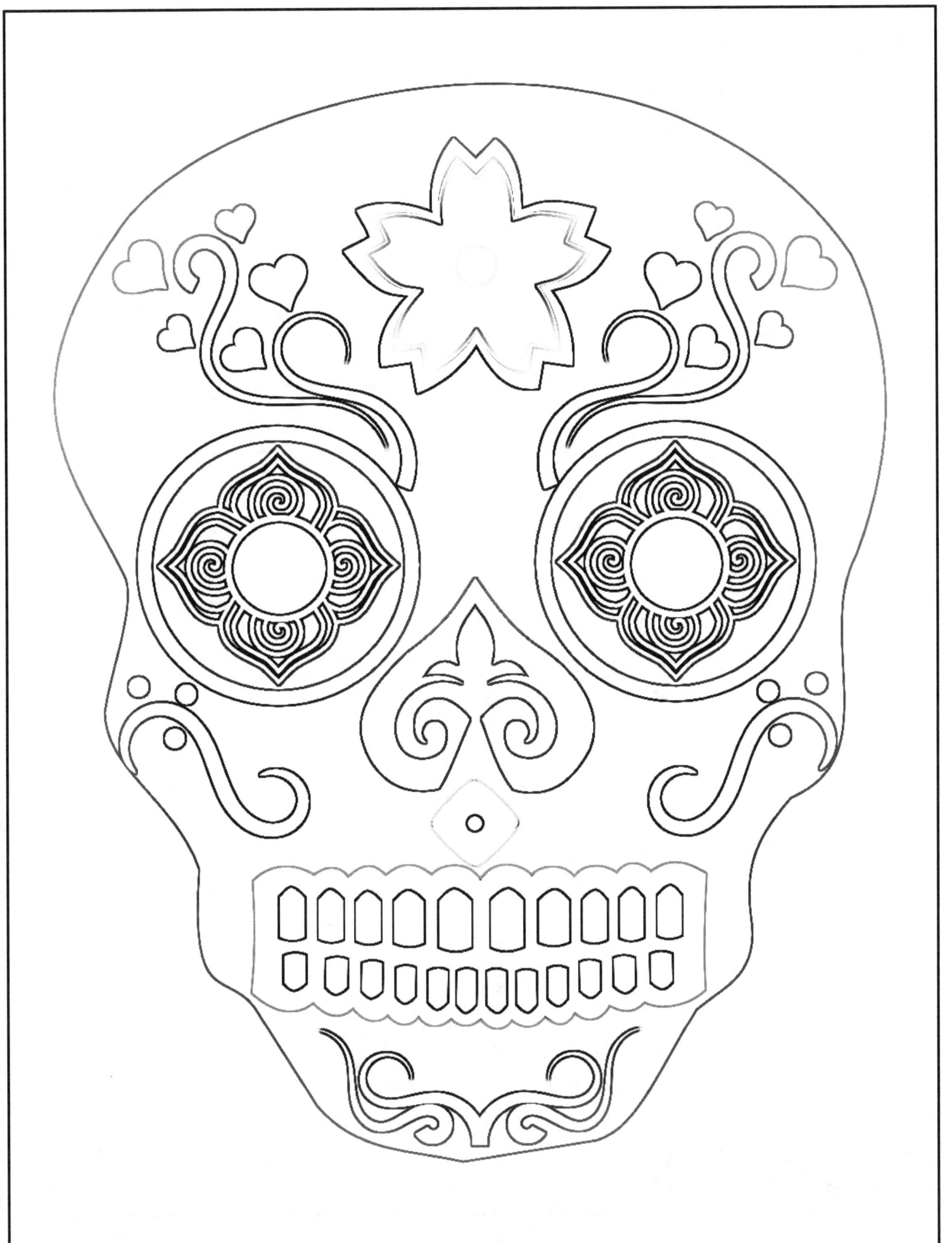

Image Title _____

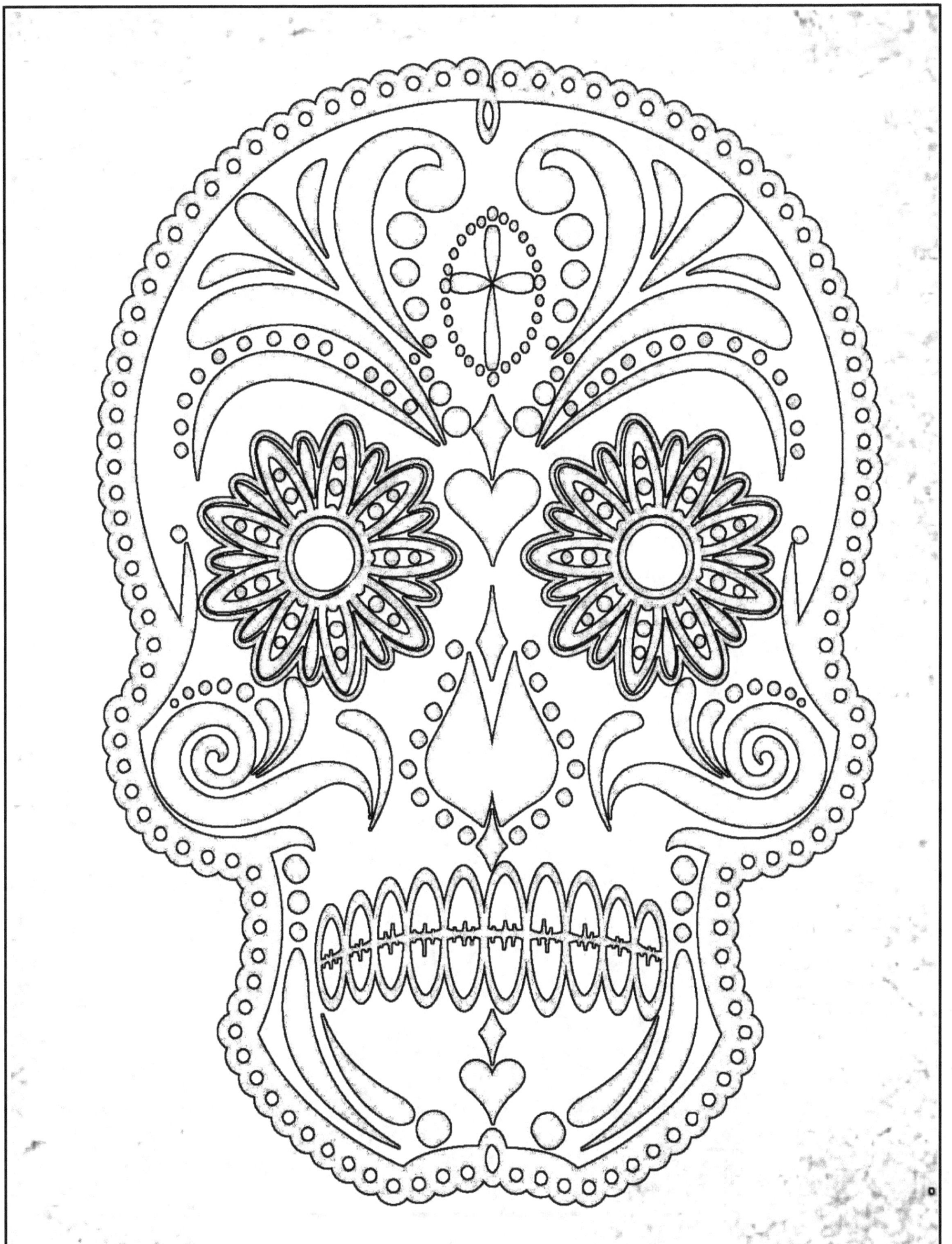

Image Title _____

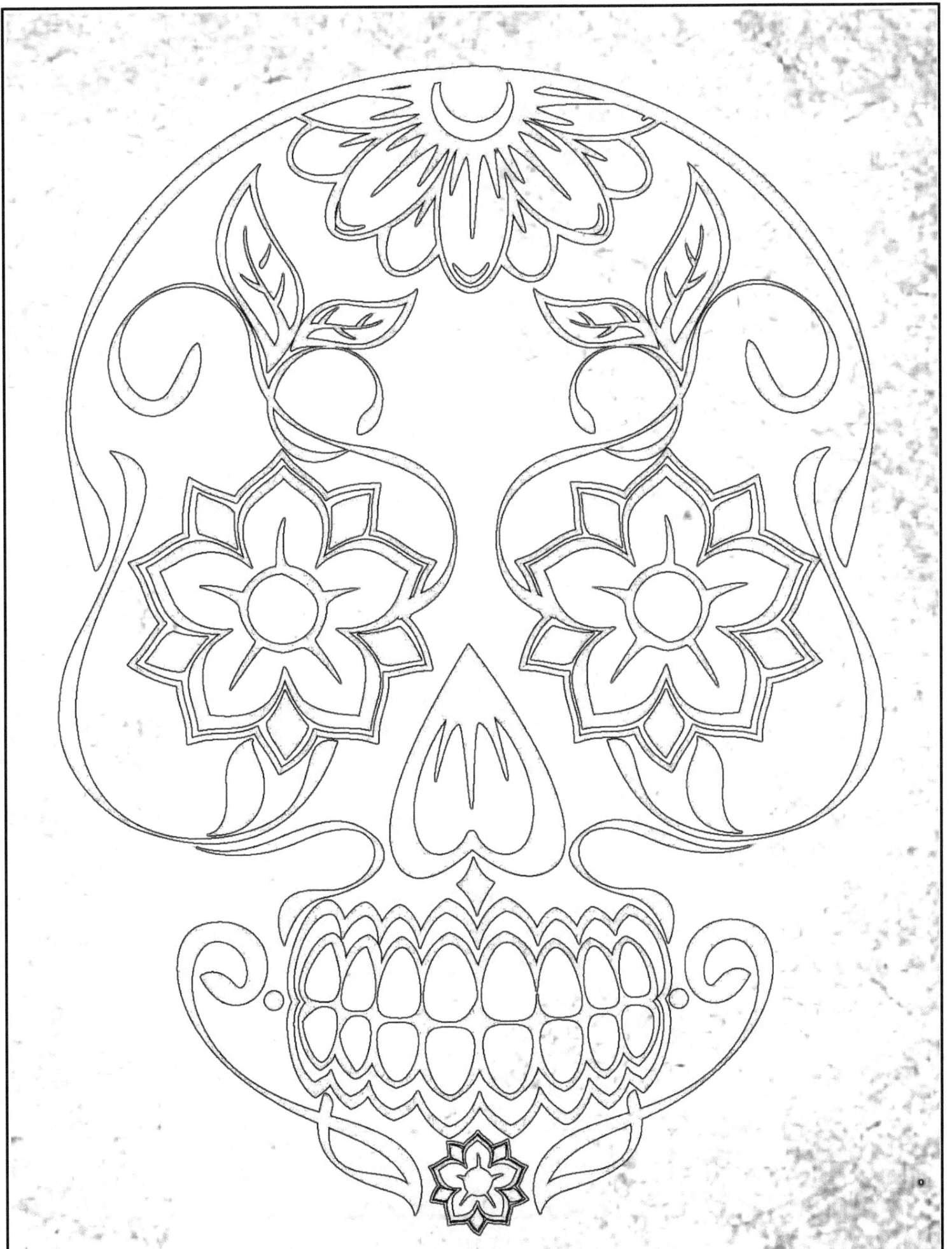

Image Title _____

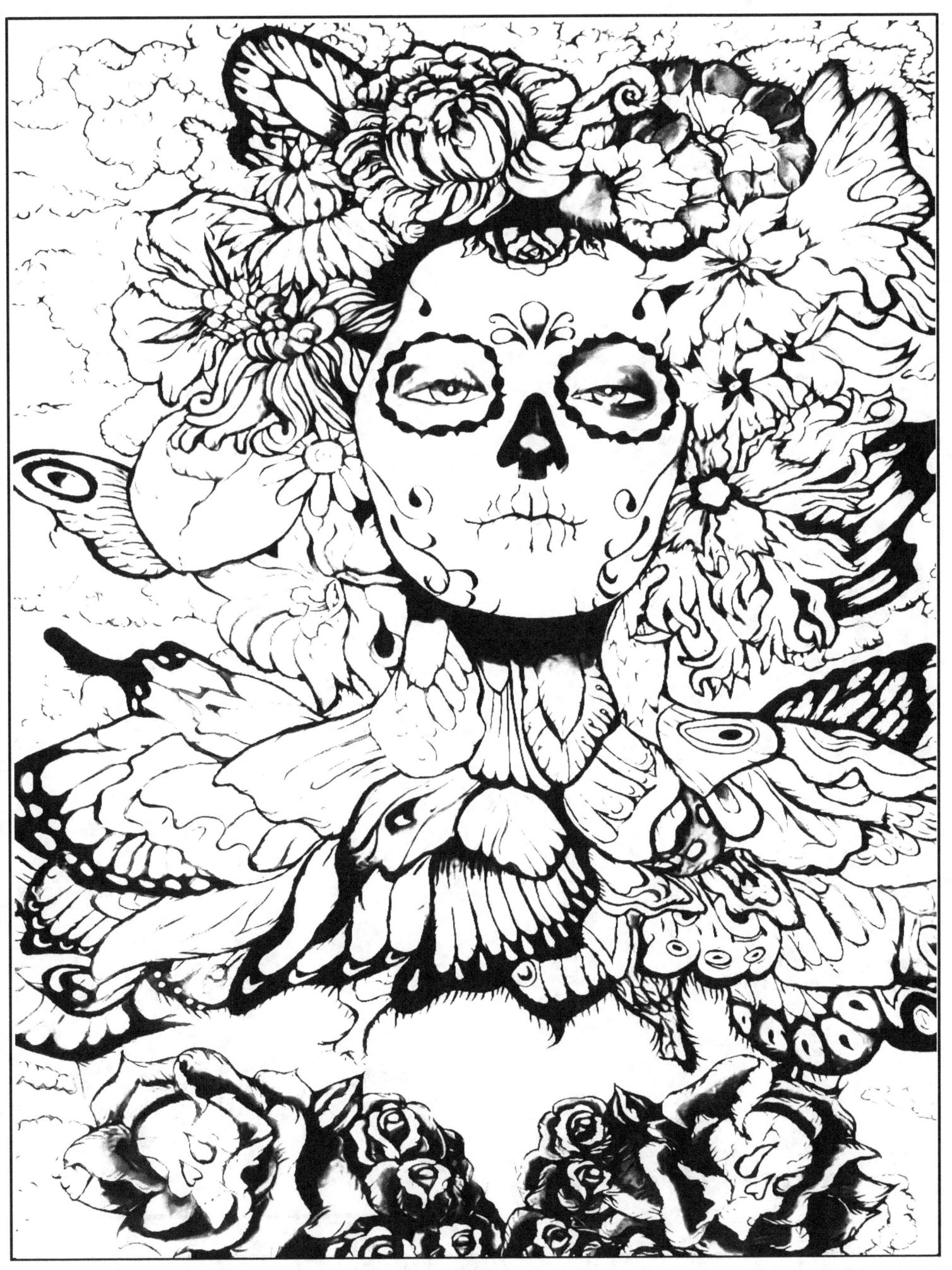

Image Title _____

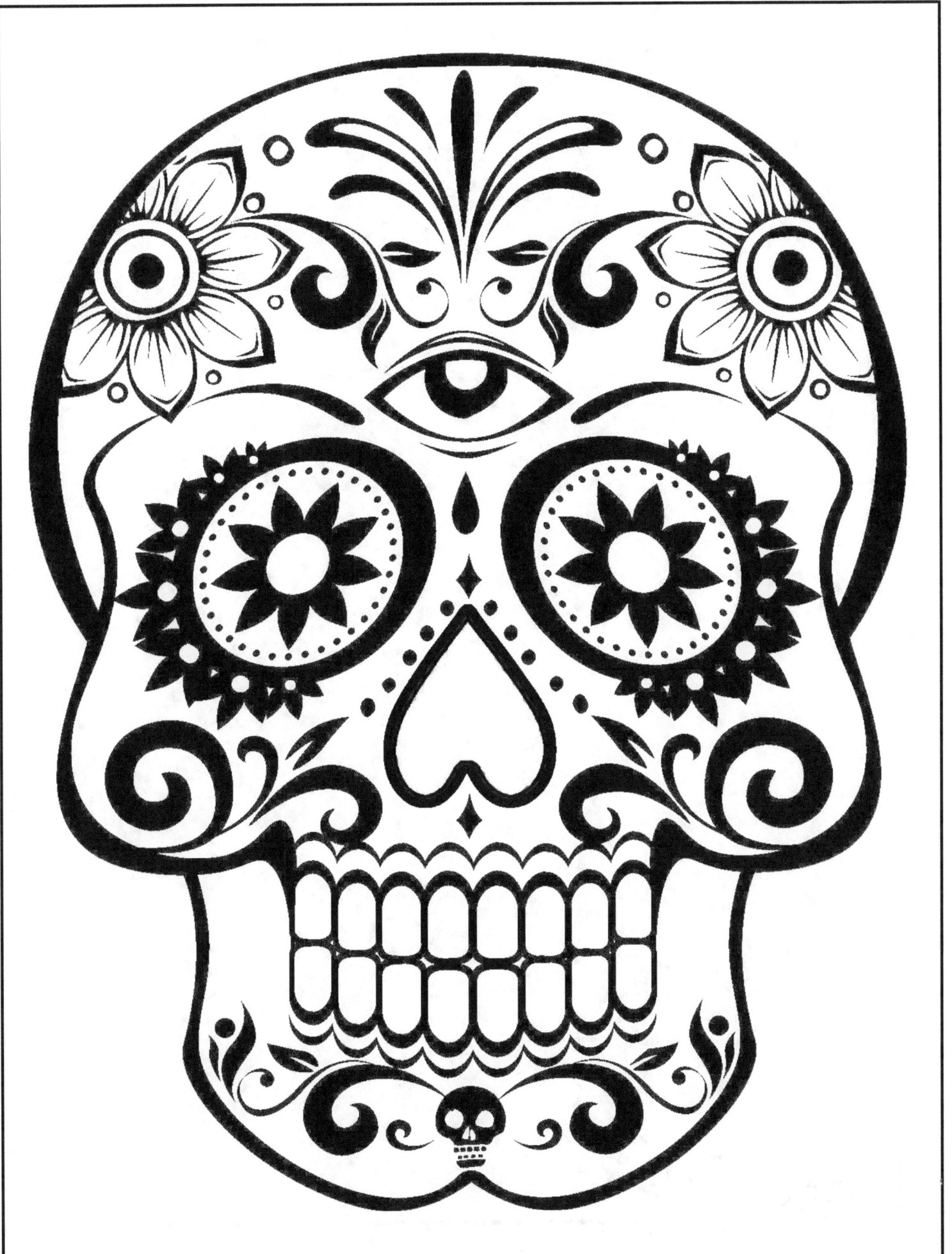

Image Title _____

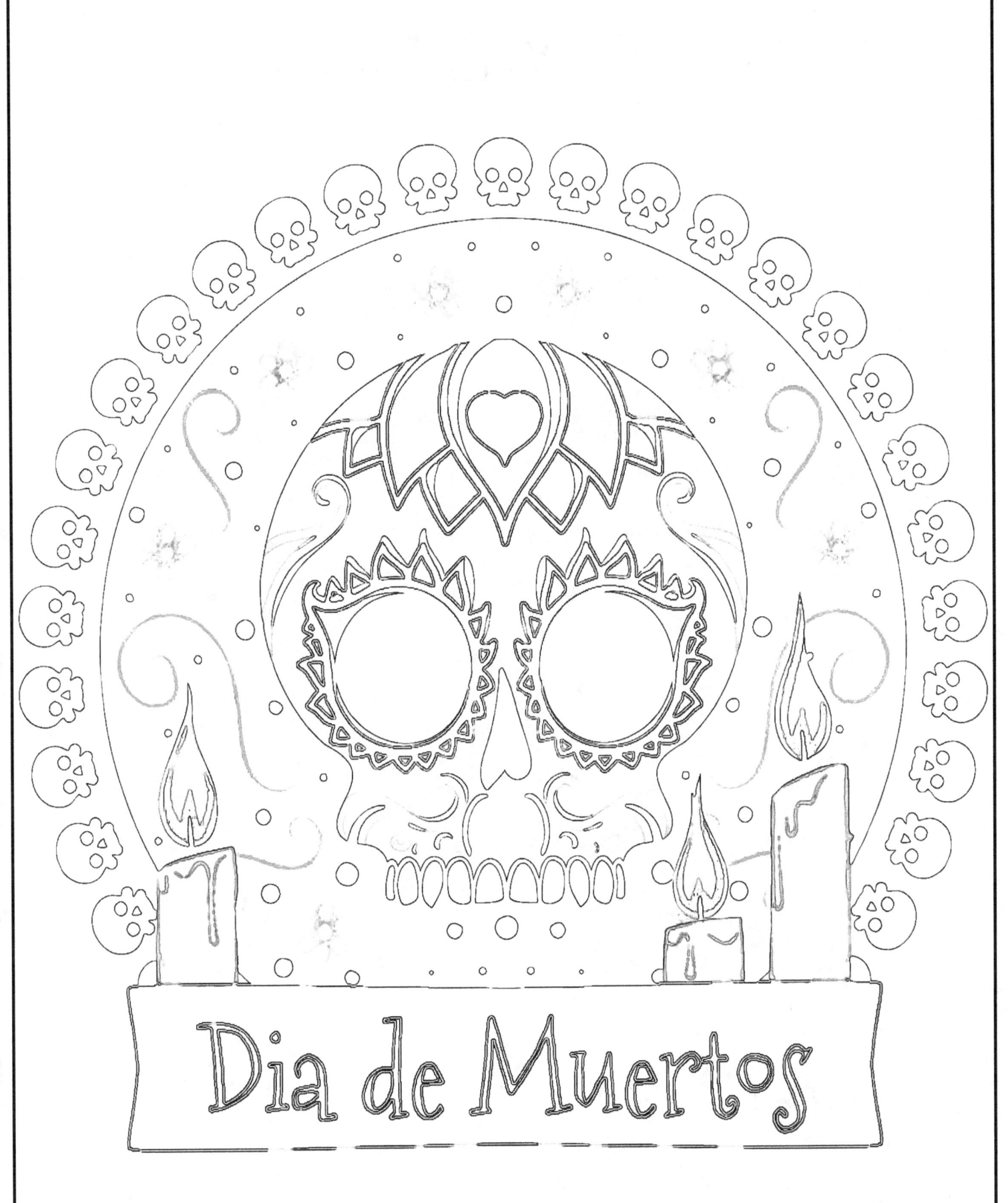

Now It's Your Turn...

Image Title _____

www.ingramcontent.com/pod-product-compliance
Lightning Source LLC
Chambersburg PA
CBHW080905220526
45466CB00011BA/3466